THOMAS KINKADE

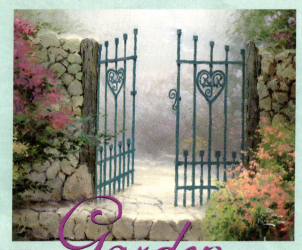

THE *Garden*
OF
Prayer

THE Garden OF Prayer

THOMAS KINKADE

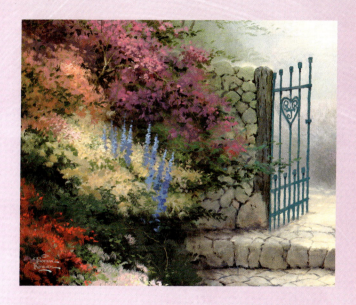

Andrews McMeel
Publishing

Kansas City

ISBN: 0-7407-3109-2

Library of Congress Control Number: 2002111558
03 04 05 06 07 TWP 10 9 8 7 6 5 4 3 2 1

Compiled by Patrick Regan

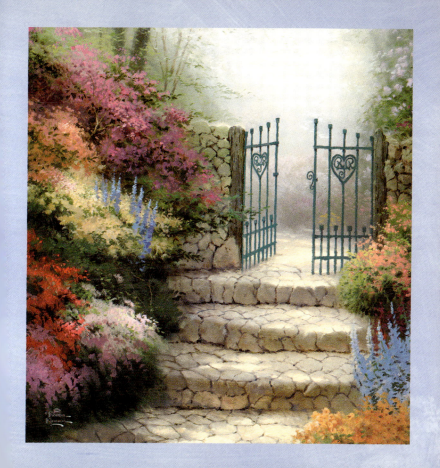

\mathscr{O}f all the ways we can bring light into our lives, I believe that none is more effective and powerful than prayer. When we pray—when we engage in an active conversation with God—pure, radiant, transcendent light streams forth, both out of us and into us.

\mathscr{I} heartily believe in the power of prayer and in its ability to add light to the canvas of our daily existence. But prayer should be more than a few minutes of conscious thought set aside at the beginning or end of the day.

When we've truly developed a loving relationship with God, the way we live *our very lives* becomes a prayer. The result of such a prayerful relationship is a level of joy unattainable on a physical level.

My prayer is that the insights, thoughts, and paintings in this book will provide inspiration and encouragement as you continue along life's wonderful journey— walking with and talking with God.

THOMAS KINKADE

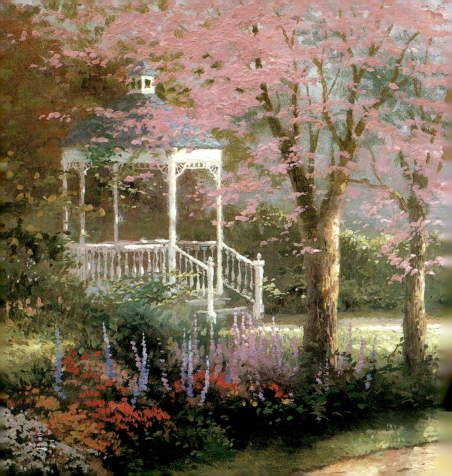

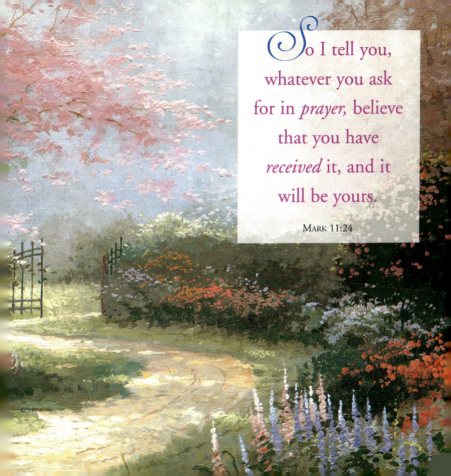

So I tell you, whatever you ask for in *prayer*, believe that you have *received* it, and it will be yours.

MARK 11:24

Prayer is not a
substitute for work,
thinking, watching,
suffering, or giving;
prayer is a *support* for
all other efforts.

GEORGE BUTTRICK

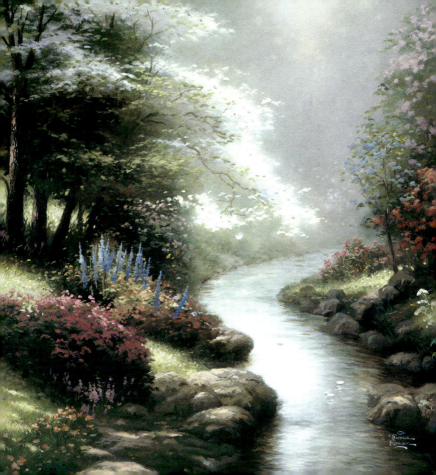

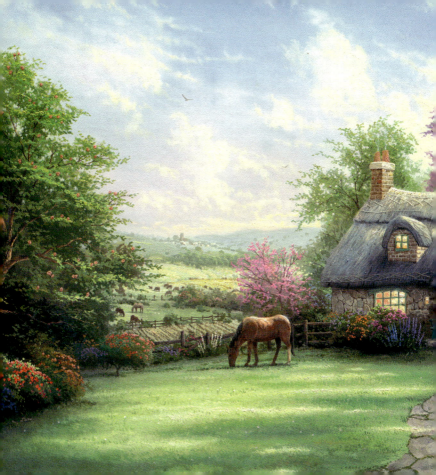

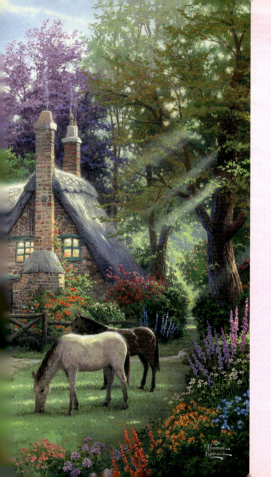

\mathcal{S}ometimes the most important thing in a whole day is the rest we take between two *deep breaths,* or the turning inwards in prayer for five short minutes.

ETTY HILLESUM

love

Take God for your spouse and friend and walk with him continually, and you will not sin and will *learn to love,* and the things you must do will work out prosperously for you.

ST. JOHN OF THE CROSS

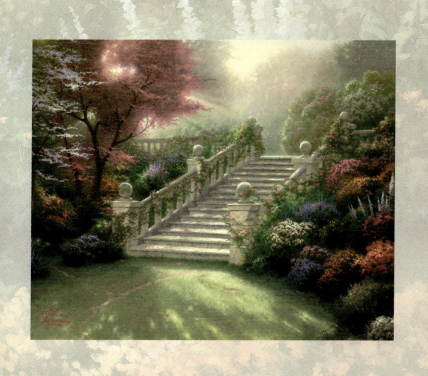

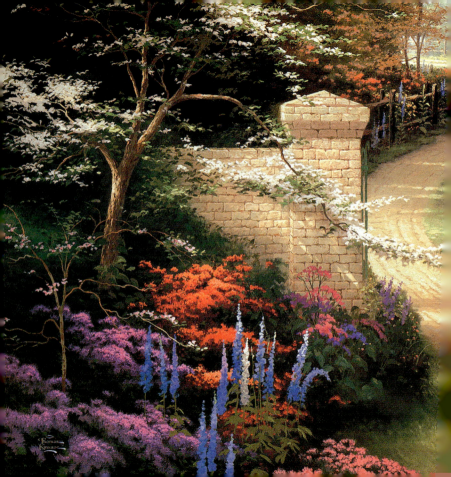

It is from *prayer*
that the spirit's
victory springs.

SCHILLERBUCH

*O*ne must learn an inner solitude,

where or with whomsoever

he may be. He must learn to

penetrate things and *find God* there,

to get a strong impression of God

firmly fixed on his mind.

MEISTER ECKHART

solitude

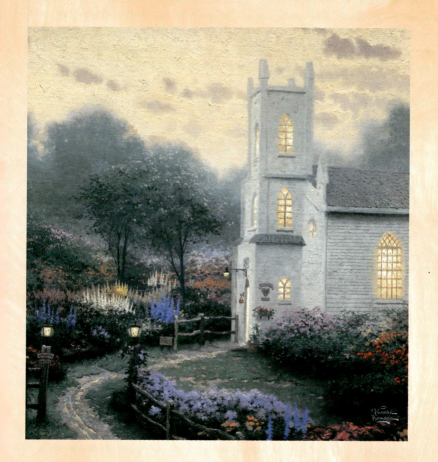

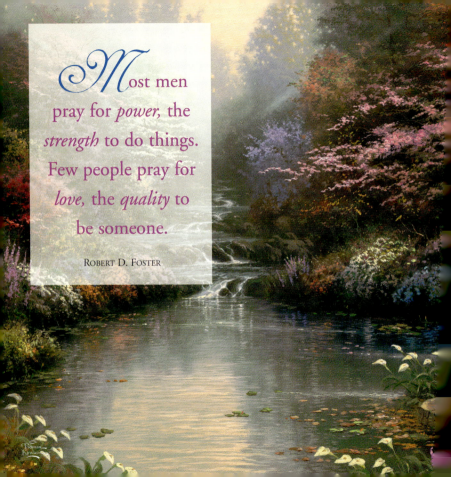

Most men pray for *power,* the *strength* to do things. Few people pray for *love,* the *quality* to be someone.

ROBERT D. FOSTER

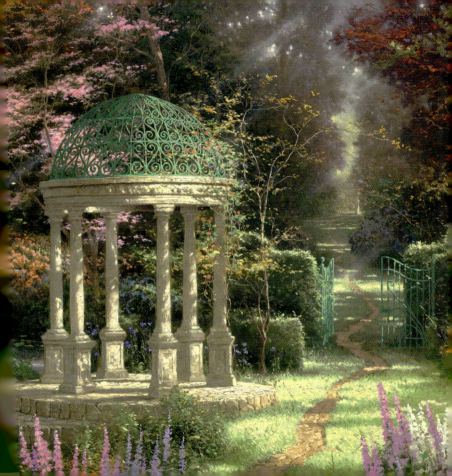

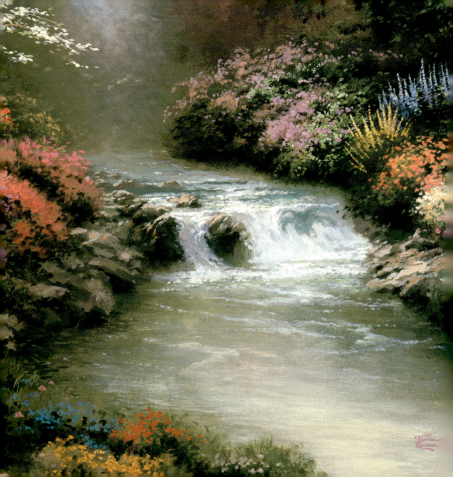

As down in the sunless
retreats of the ocean
Sweet flowers are *springing* no
mortal can see,
So deep in my *soul* the still
prayer of *devotion,*
Unheard by the world,
rises silent to Thee.

THOMAS MOORE

devotion

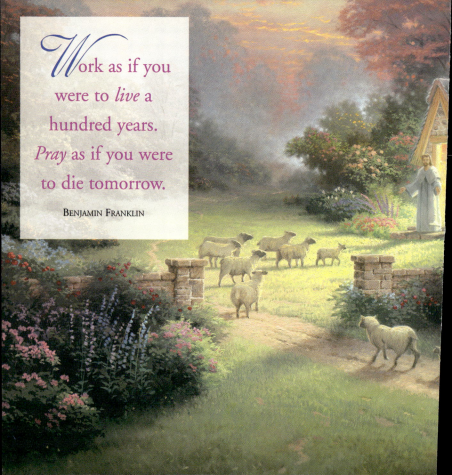

*W*ork as if you
were to *live* a
hundred years.
Pray as if you were
to die tomorrow.

BENJAMIN FRANKLIN

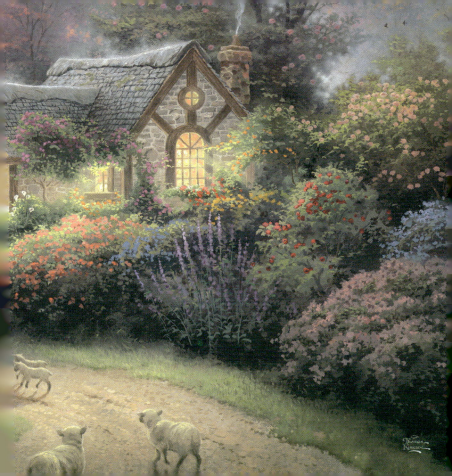

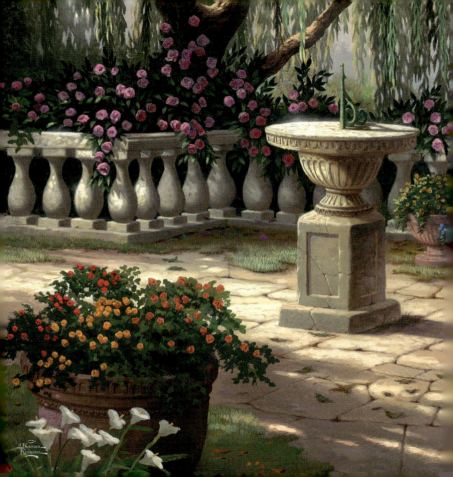

*L*et everyone try and find that as a result of *daily prayer* he adds something new to his life, something with which nothing can be compared.

MOHANDAS K. GANDHI

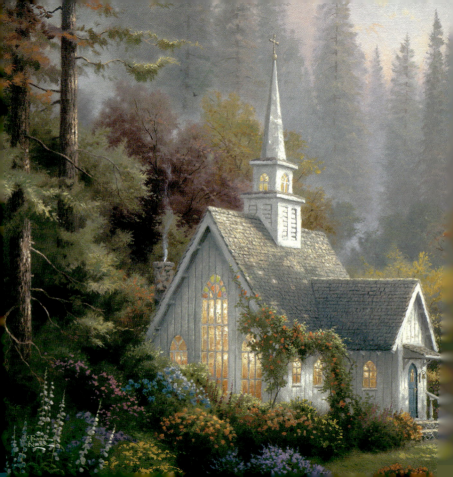

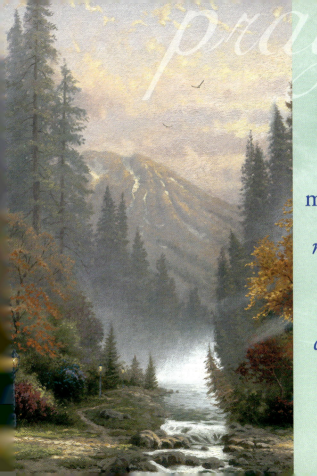

prayer

Do not make prayer a *monologue*— make it a *conversation.*

AUTHOR UNKNOWN

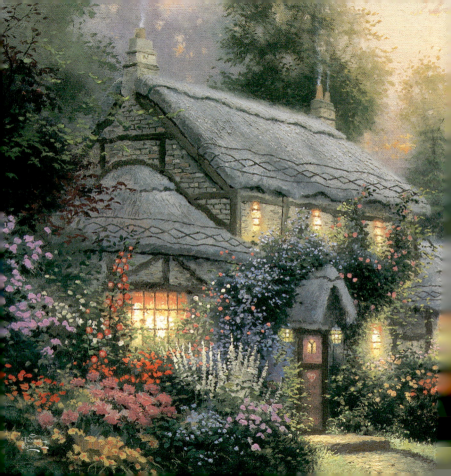

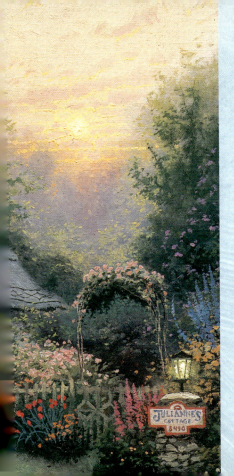

bless

*I*f you truly want
to *bless* others in your
life, you must seek
out those *experiences*
that keep you
motivated and
inspired.

THOMAS KINKADE

*T*he men who have *guided* the *destiny* of the United States have found the *strength* for their tasks by going to their knees. This private unity of public men and their God is an enduring source of *reassurance* for the people of America.

LYNDON B. JOHNSON

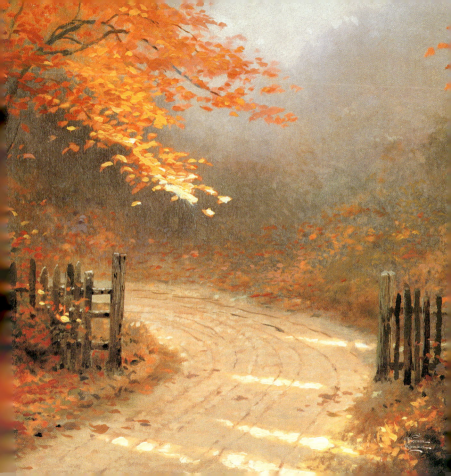

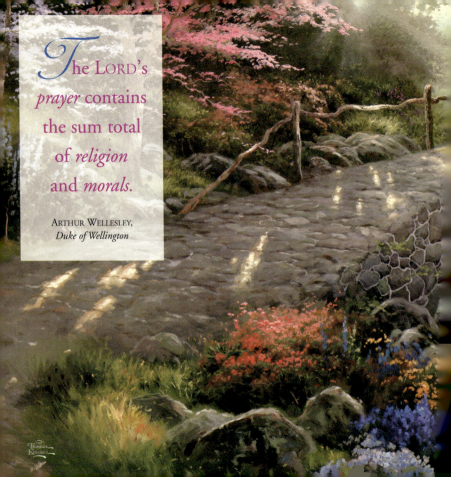

The LORD's *prayer* contains the sum total of *religion* and *morals.*

ARTHUR WELLESLEY,
Duke of Wellington

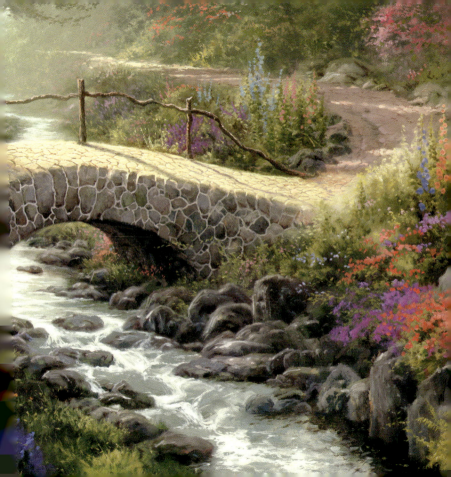

Prayer . . . makes a *sour* heart *sweet,* a *sad* heart *merry,* a *poor* heart *rich,* a *foolish* heart *wise,* a *timid* heart *brave,* a *sick* heart *well,* a *blind* heart *full of sight,* a *cold* heart *ardent.* It draws down the great GOD into the little heart.

MECHTHILD OF MAGDEBURG

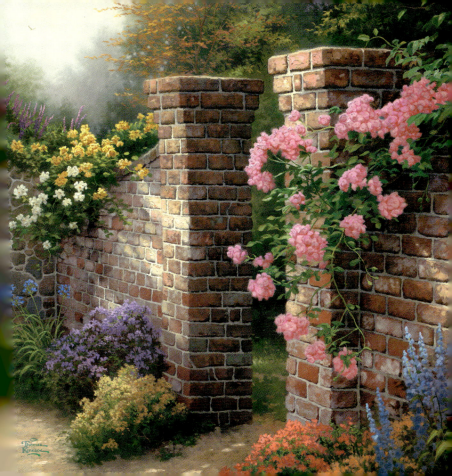

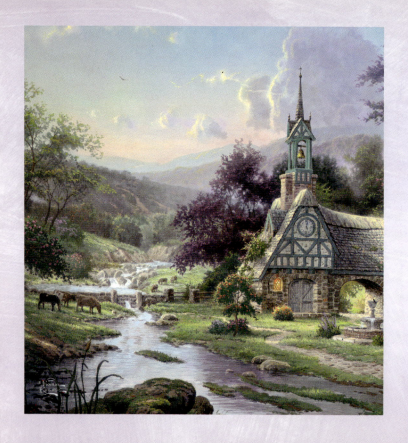

Gratitude bestows *reverence*,
allowing us to *encounter*
everyday *epiphanies*, those
transcendent moments of awe
that change forever how we
experience life and the world.

JOHN MILTON

Gratitude

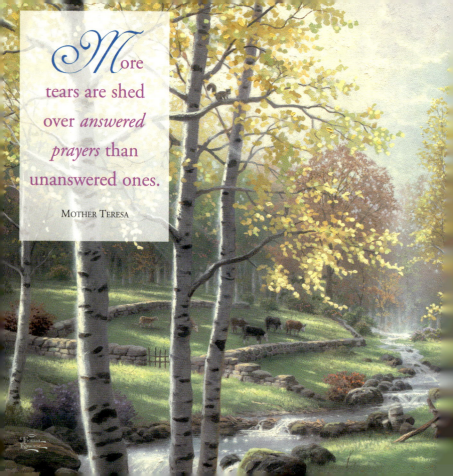

\mathcal{M}ore
tears are shed
over *answered*
prayers than
unanswered ones.

MOTHER TERESA

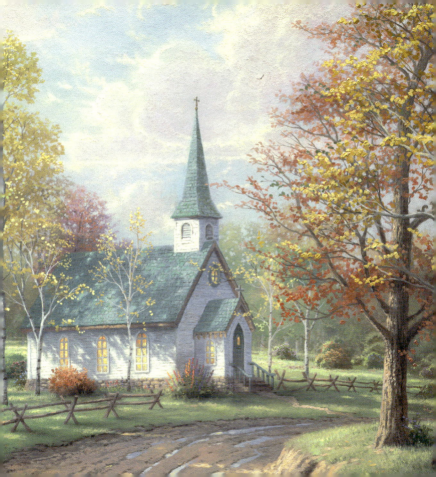

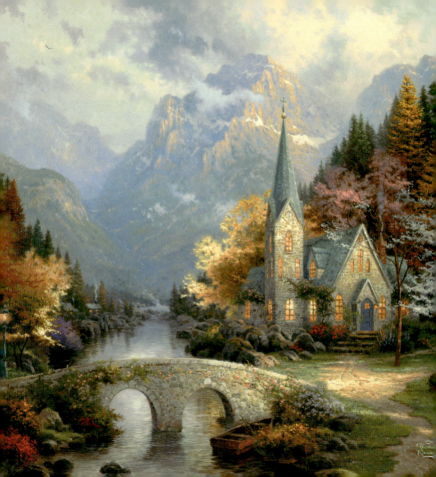

Prayer

We are all weak, finite, simple human beings, standing in the need of prayer. None need it so much as those who think they are strong, those who know it not, but are deluded by self-sufficiency.

HAROLD C. PHILLIPS

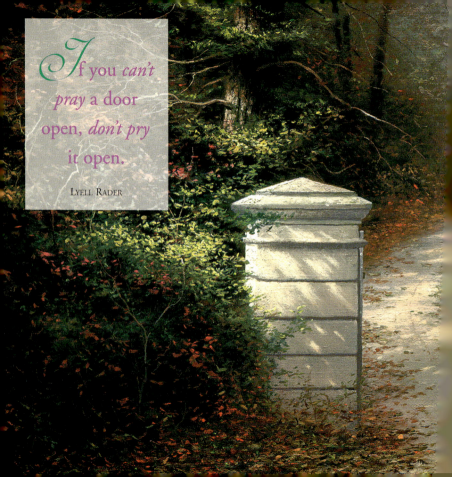

*I*f you *can't* *pray* a door open, *don't pry* it open.

LYELL RADER

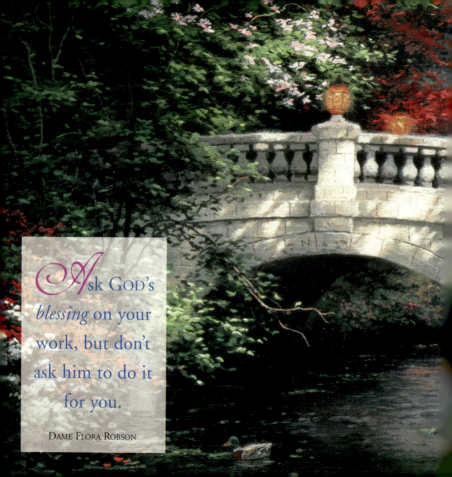

\mathcal{A}sk GOD's *blessing* on your work, but don't ask him to do it for you.

DAME FLORA ROBSON

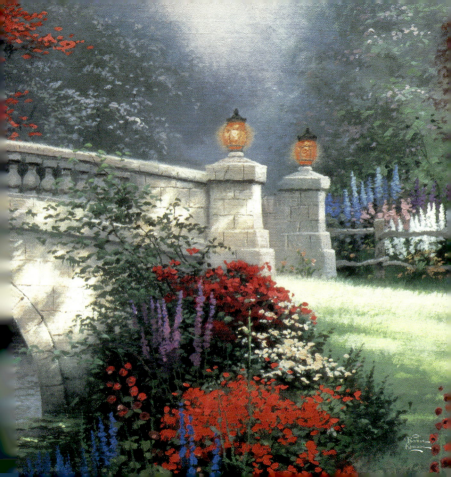

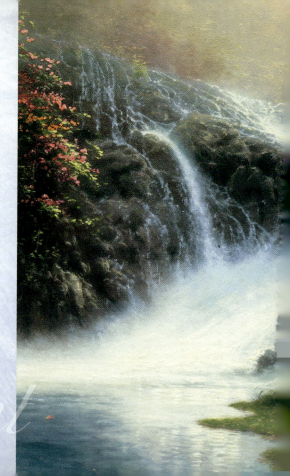

Prayer should be short, without giving GOD *Almighty* reasons why he should *grant* this, or that; he knows best what is good for us.

JOHN SELDEN

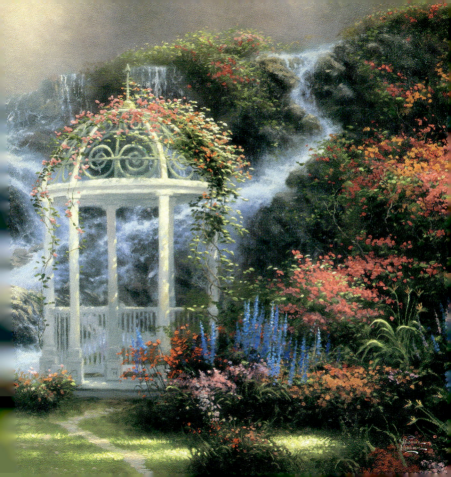

God

Prayer is *talking* with GOD and telling him you *love* him, *conversing* with GOD about all the things that are *important* in *life,* both large and small, and being *assured* that he is *listening.*

C. NEIL STRAIT

listening

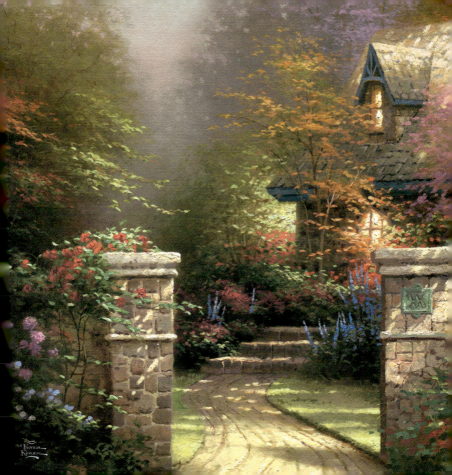

Thomas Kinkade

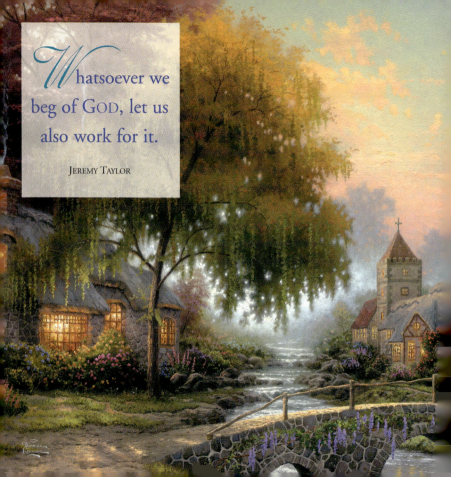

Whatsoever we beg of GOD, let us also work for it.

JEREMY TAYLOR

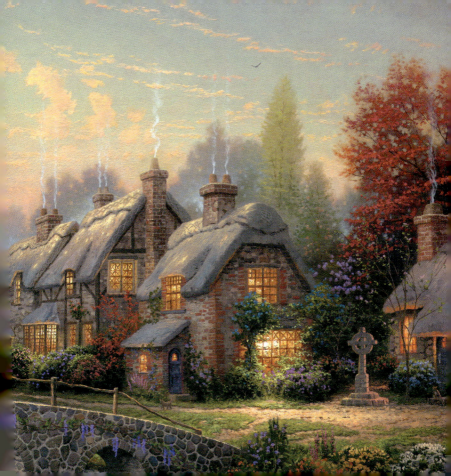

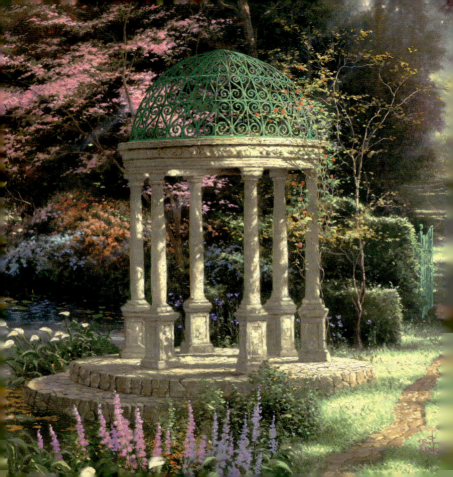

*T*he *influence* of *prayer* on the human mind and body is as demonstrable as that of secreting glands. Its results can be measured in terms of increased *physical buoyancy,* greater *intellectual vigor, moral stamina,* and a deeper understanding of the *realities* underlying human relationships.

DR. ALEX CARREL

Relationships

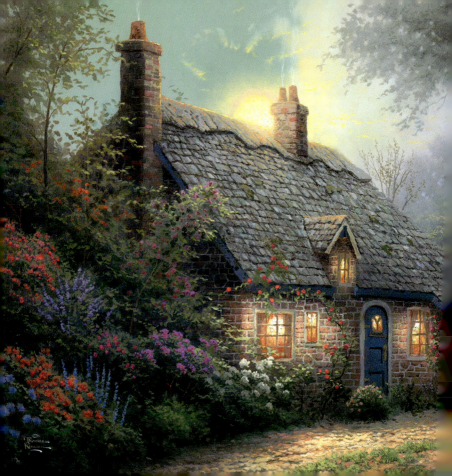

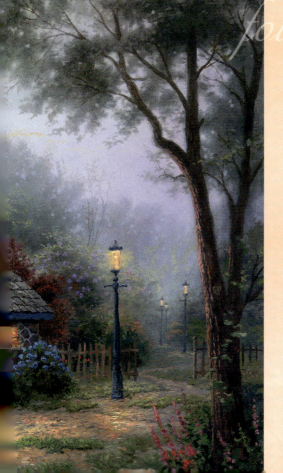

foundations

*W*e turn to GOD for *help* when our *foundations* are shaking, only to *learn* that it is GOD who is shaking them.

CHARLES C. WEST

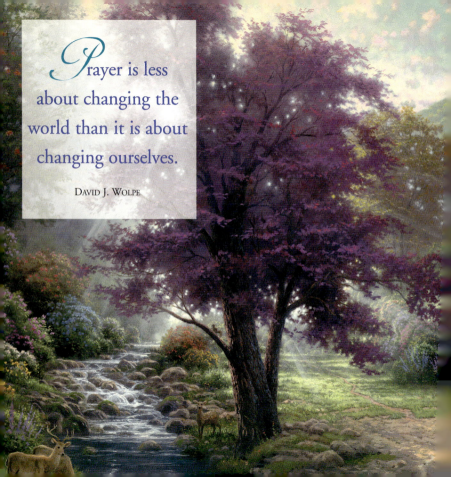

*P*rayer is less about changing the world than it is about changing ourselves.

DAVID J. WOLPE

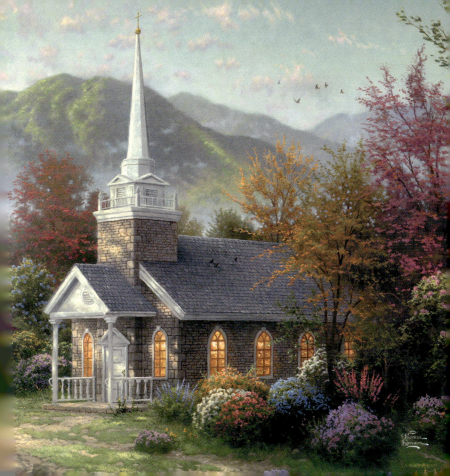

heart

*P*rayer is not asking. It is a longing of the *soul*. It is daily admission of one's weakness. . . . It is better in prayer to have a heart without words than words without a *heart*.

MOHANDAS K. GANDHI

soul

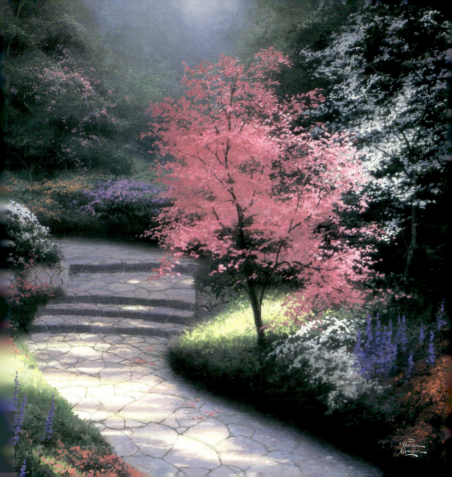

Thomas Kinkade

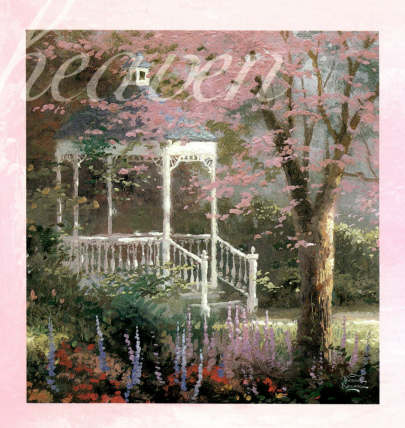

*Prayer is the fair and radiant daughter of all the human virtues, the arch connecting *heaven and earth,* the sweet companion that is alike the *lion and the dove;* and prayer will give you the key of heaven.*

HONORÉ DE BALZAC

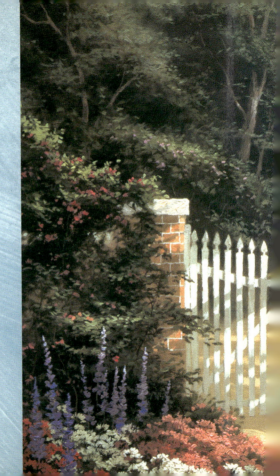

joy

*P*rayer is
The world
in tune,
A spirit-voice,
And *vocal joys,*
Whose echo is
Heaven's bliss.

HENRY VAUGHAN

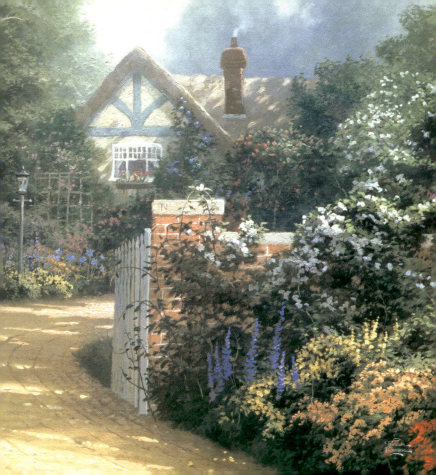

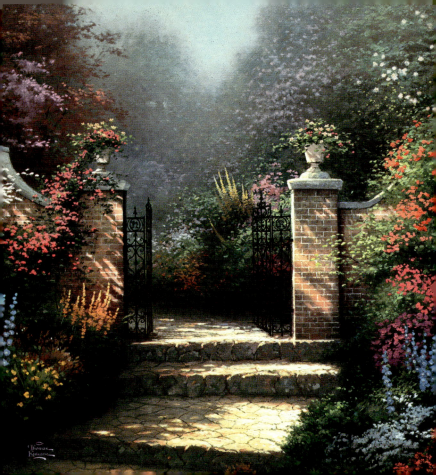

To give *thanks* in *solitude* is enough. *Thanksgiving* has wings and goes where it must go. Your *prayer* knows much more about it than you do.

VICTOR HUGO

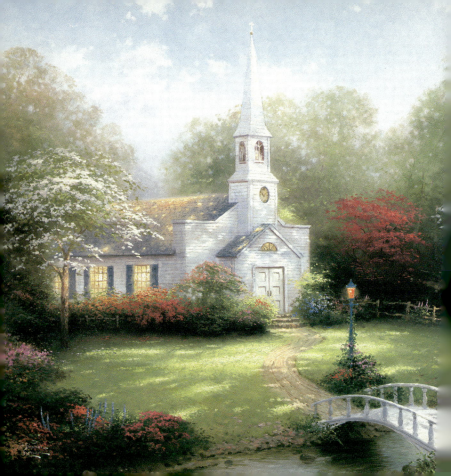

GOD is waiting eagerly to respond with new *strength* to each little act of *self-control*, small *disciplines* of prayer, feeble searching after him. And his children shall be filled if they will only hunger and thirst after what he offers.

RICHARD HOLLOWAY

And

prayer is more

Than an order

of words,

the conscious

occupation

Of the praying

mind, or the

sound of the

voice praying.

T. S. ELIOT

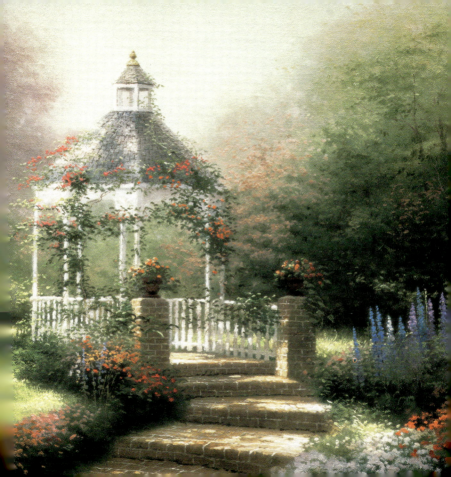

Is not prayer also a study of *truth*—a sally of the *soul* into the unfound infinite? No man ever prayed heartily without *learning* something.

RALPH WALDO EMERSON

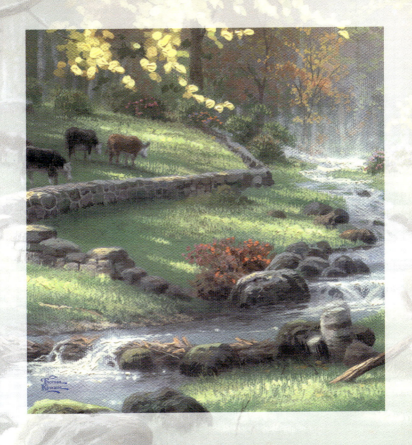

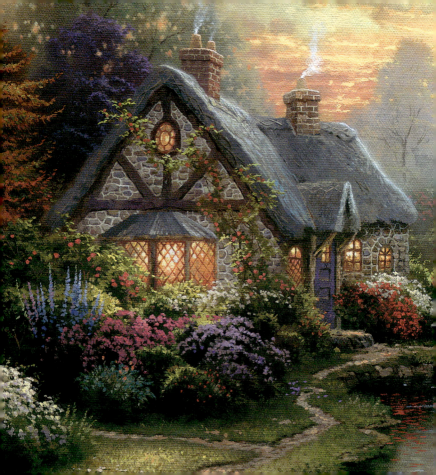

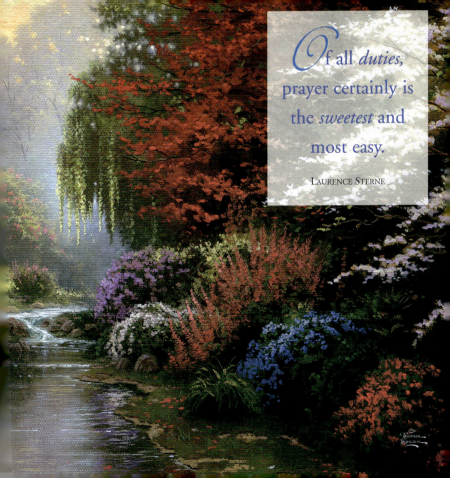

*O*f all *duties,* prayer certainly is the *sweetest* and most easy.

L<small>AURENCE</small> S<small>TERNE</small>

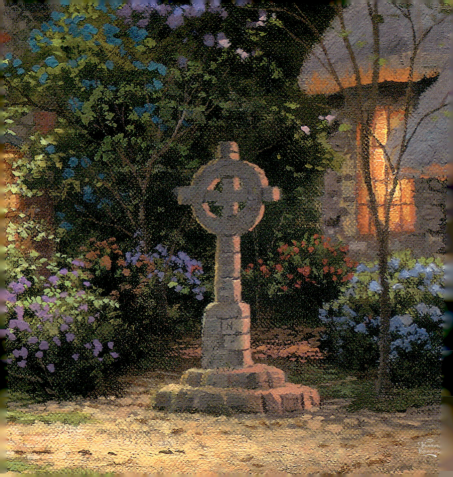

In a world of prayer,
we are all *equal* in the sense
that each of us is a unique
person, with a unique
perspective on the world,
a member of a *class of one.*

W. H. AUDEN

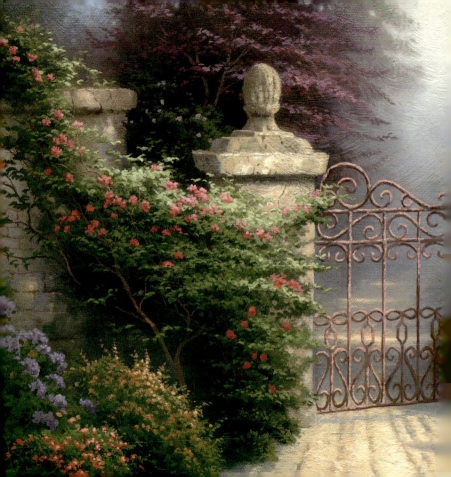

*D*o not worry about anything, but in everything by *prayer* and *supplication* with *thanksgiving* let your requests be made known to GOD.

PHILIPPIANS 4:6

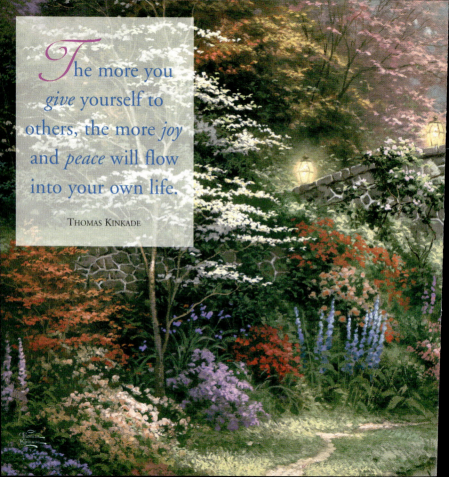

*T*he more you
give yourself to
others, the more *joy*
and *peace* will flow
into your own life.

THOMAS KINKADE

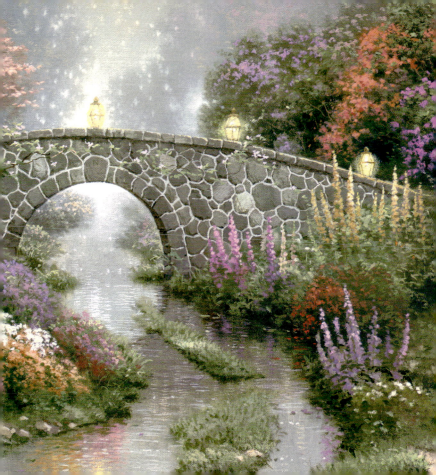

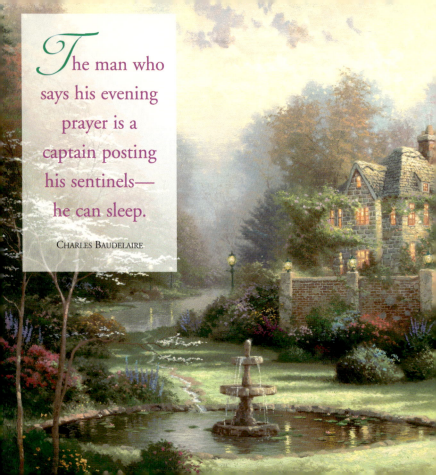

The man who says his evening prayer is a captain posting his sentinels—he can sleep.

CHARLES BAUDELAIRE

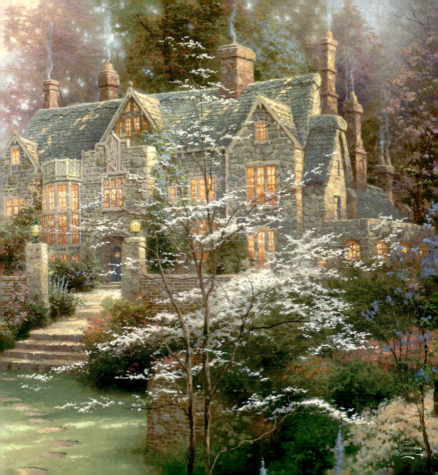

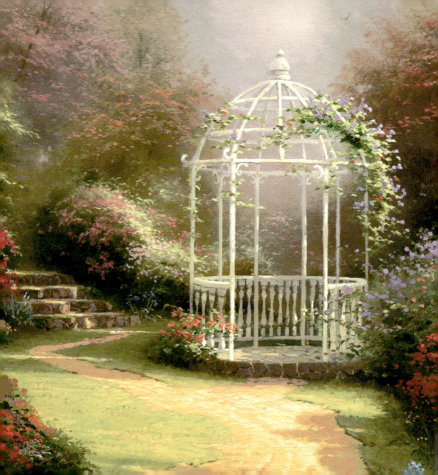

glory

It is not only prayer that gives God glory but work. Smiting on an anvil, sawing a beam, whitewashing a wall, driving horses, sweeping, scouring, everything gives God some glory if being in his grace you do it as your duty.

GERARD MANLEY HOPKINS

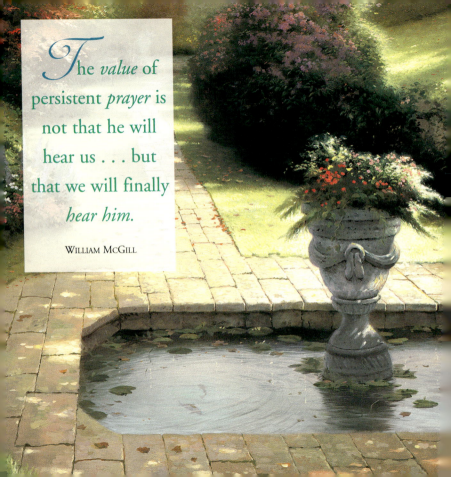

The *value* of persistent *prayer* is not that he will hear us . . . but that we will finally *hear him.*

WILLIAM McGILL

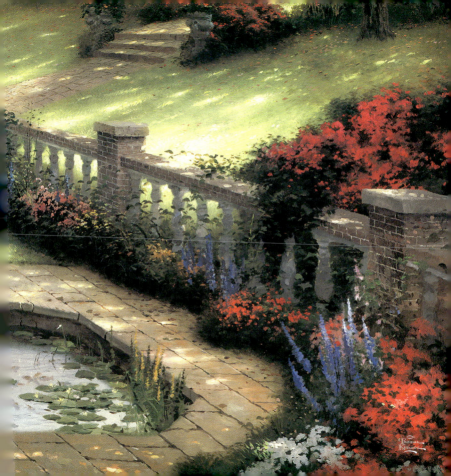

*P*RAYER IS THE BURDEN OF A SIGH,

THE FALLING OF A TEAR,

THE UPWARD GLANCING OF AN EYE

WHEN NONE BUT GOD IS NEAR.

JAMES MONTGOMERY

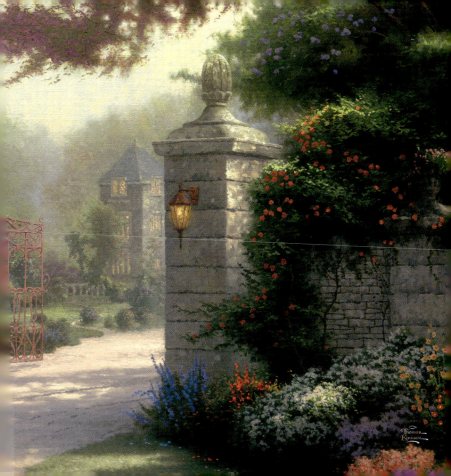

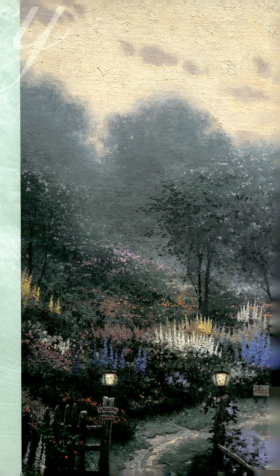

mercy

*W*e do *pray*
for *mercy,*

And that same
prayer doth
teach us all to
render

The deeds of
mercy.

WILLIAM SHAKESPEARE

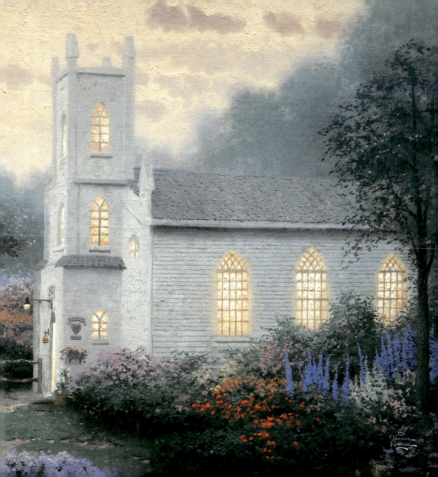

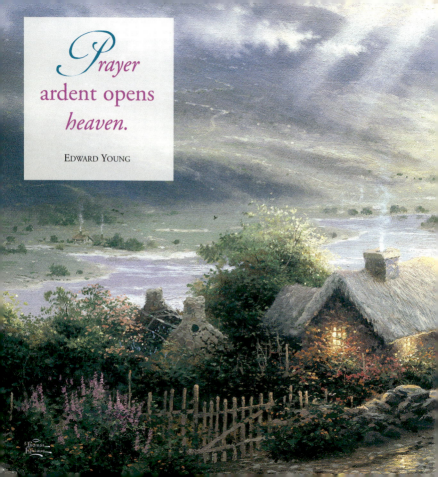

Prayer
ardent opens
heaven.

EDWARD YOUNG

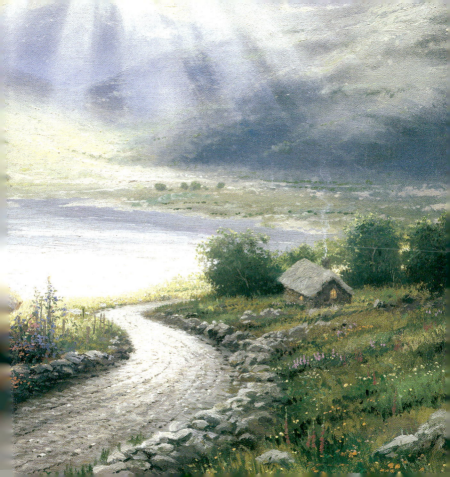

*A*s soon
as the man is
at one with
GOD, he will
not beg.
He will then
see *prayer* in
all *action.*

RALPH WALDO EMERSON

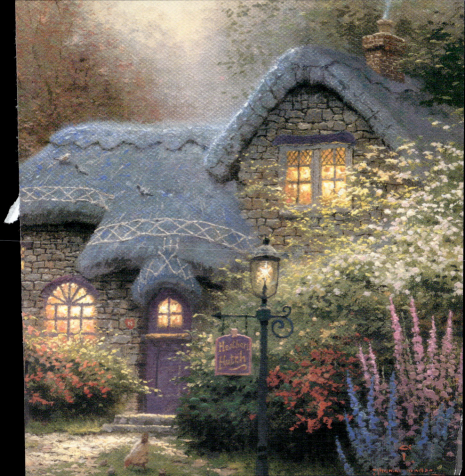

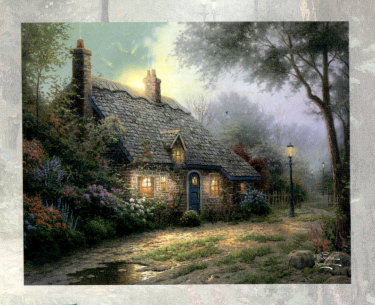

*T*hey who have steeped their souls in prayer

Can every anguish calmly bear.

RICHARD MONCKTON MILNES HOUGHTON